Once upon a TIME

The way America was.

by ERIC SLOANE

Dover Publications, Inc.
Mineola, New York

Other books by Eric Sloane available as Dover reprints

A Museum of Early American Tools
American Barns and Covered Bridges
American Yesterday
A Reverence for Wood
Look at the Sky and Tell the Weather
Our Vanishing Landscape
Diary of an Early American Boy: Noah Blake 1805
The Seasons of America Past
The Cracker Barrel

(Log on to **www.doverpublications.com** for more information.)

Copyright

Copyright © 1982 by Eric Sloane
All rights reserved.

Bibliographical Note

This Dover edition, first published in 2005, is an unabridged republication of the work originally published in 1982 by Hastings House Publishers, New York.

Library of Congress Cataloging-in-Publication Data

Sloane, Eric.
 Once upon a time : the way America was / Eric Sloane.
 p. cm.
 "An unabridged republication of the work originally published in 1982 by Hastings House Publishers, New York"—T.p. verso.
 ISBN 0-486-44411-2 (pbk.)
 1. National characteristics, American. 2. United States—Civilization. 3. United States—Social life and customs. I. Title.
E169.1.S5936 2005
973—dc22

2005047089

Manufactured in the United States of America
Dover Publications, Inc., 31 East 2nd Street, Mineola, N.Y. 11501

Dedicated to the American Spirit

AUTHOR'S NOTE

Author's note

This is a book about once-upon-a-time in America. It is also about what we now like to refer to as "the American heritage." We are bombarded with that phrase in school, at home and in church: you see it in advertisements for furniture and home decoration, and any child worth his salt as a thinker might begin to wonder what this "American heritage" is all about. It becomes more confusing too, when we realize that most "American things" actually originated abroad. Hot dogs started in Holland, apple pie began in Germany, and the first covered bridge was in Switzerland. Almost nothing, it seems, can be identified as being completely American.

It was once thought that the rocking chair was an American invention (by Benjamin Franklin) but Ben really copied the idea from a Dutch cradle-rocker. The first rocket engine was German, the first jet airplane was English and the first helicopter flight happened abroad. The first satellites were Russian and China was using rockets

in the thirteenth century. This American heritage does certainly not depend upon inventions or home furnishings; in fact, it is nothing you can see at all because it is an invisible *spirit*.

Once upon a time when all nations consisted of kings and queens and emperors, lords and all the common people who served under them, a new spirit was born. The idea of a government in which everyone would be completely equal, was unheard of then. The American's sudden legacy of freedom and equality made him a different and special citizen of the world who would leave behind him a heritage and a national spirit of extraordinary value.

A simple American farmer could own his land and have voice in the laws of the government. His regard for this newfound independence, his devotion to God, his reverence for home and love of hard work made him quite a fellow that the rest of the world looked up to. Everyone in America could be equal to kings and queens abroad; and this, in short, is the heritage which we often take for granted and manage sometimes to forget.

It becomes easy to forget our everyday existence when so many things are done for us: life becomes dull because we are robbed of the pleasure of doing things for ourselves. The government is doing more for us now than we realize, even more than a self-reliant person might wish. You cannot help men permanently by doing for them what they could and should do for themselves. Less self-reliant now, we feel less important than we used to. Back in pioneer days we were completely aware of our self-dependence because everything we ate and drank, everything we wore, almost everything we touched were results of our own labor. We had reason to believe we were pretty important in those days.

What a bore life has become! When we turn on a water faucet we have no idea where the water comes from. When we want light, we simply flick a switch without knowing where the power came from. Our clothes might come from Chicago or Hong Kong but we couldn't care less: our food comes from somewhere by truck or

train—what's the difference? The actual difference is that if you had dug your own well, you would savor that water like fine wine. If you made your own candles for light, you'd enjoy the fruits of your labor, prizing those candles, actually enjoying the light they gave. If your father raised the sheep and your mother spun the wool to make your socks and your suit, you'd be pretty proud of them and never think of discarding them even when worn out. A house and furniture made from trees you felled yourself would become museum pieces to you. Your whole life would be full of the evidences of your own value, therefore your life would be richer and more meaningful. Such was the awareness and spiritual richness of early days that does not exist today.

How now, can we hope to regain this lost awareness? How can we rediscover the old truths? None of us can hope to grow our own trees, fell them to build our own houses or furniture and few can hope to dig our own wells. Few of us city dwellers can even grow our own vegetables. But in spite of all the computers and modern science that make our life easier, it need not dull our heritage of the American spirit as long as we do not forget the vanished joys of pioneer life and *the way the early American lived and thought.* After all, we are the same sort of human being with capability of experiencing the old–time spirit. We just need reminding, and that is the object of this book, to remember and revive the wonderful awareness of once-upon-a-time.

<div style="text-align:right">
Eric Sloane

Cornwall Bridge

Connecticut
</div>

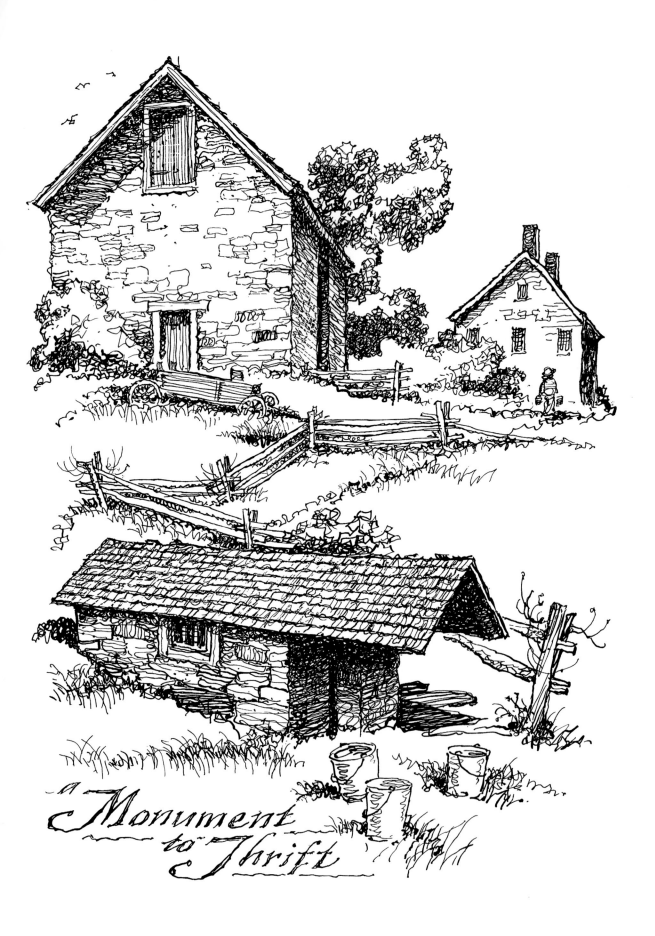

CHAPTER ONE

Once upon a time Americans were Frugal.

Once upon a time, believe it or not, America was frugal. While most nations of the world were setting sail in search of treasure and plundering foreign lands for gold, the New World countryside was developing a philosophical religion of not wasting and being satisfied with what God affords those who work for it. Being content with no more than what was needed became an early American trait, almost a national creed. One ancient farm almanack said it in rhyme: "The devil damns the man who lives by greed, Jehovah loves the man who only fills his need."

Without greed, the early American and his farmstead were a noble monument to thrift. It might not have appeared so to the average European because there was such evidence of wealth here; there were enormous well-stocked barns, some even larger than the European tithe-barns owned by the church and the lords who collected taxes in hay or grain. Simple outbuildings were built with massive beams to last for centuries and farm dwellings were overflowing

with all the necessities of life. But there was *nothing unnecessary,* nothing not worth saving and not a thing was *wasted.* Every chair, each table and rug, every dish and each tiny household item was carefully chosen, well designed and made by hand to be saved for future generations. How unlike our life today!

Nowadays we pass off the finesse of early craftsmanship with an expert wave of the hand, saying, "oh they made things so well because they had *all the time in the world!"* That, of course, is completely untrue for they had only about a tenth of the time that we have today. There was no proper lighting for night work, no power tools and no electric time-savers. Average transportation was no faster than a man walks. Work days depended completely upon sunlight and proper weather. A man began each day's work only after doing (what we'd now consider a whole day's labor) necessary farm chores. Even his lifespan was shorter. Their secret was making each moment count and *not wasting a second.*

Waste, which was once-upon-a-time deplorable, has now become almost fashionable as a national habit. We often waste more in one month than the average old-timer saved during his lifetime. Waste was once considered bad manners, the mark of a fool and something quite un-American. Some of us have been fooled into the theory that the more we waste, the more we need to buy and so waste therefore aids the national economy—a sort of "economic pursuit." Abraham Lincoln foresaw this theory when he said: "You cannot bring about prosperity by discouraging thrift."

Would you believe it, once-upon-a-time there was no such thing as *garbage* as we now know it: old dictionaries listed the word garbage as "the entrails of animals." At the same time there was no such thing as *junk* as we now know it for old dictionaries listed the word junk as "odds and ends of rope." George Washington would find it hard to believe that "the entrails of animals" would some day become varied waste matter costing the nation two thousand times

more annually than what it cost him to run the whole country. How surprised he'd be to find that what used to be "odds and ends of rope" would become a waste material business very important to the national economy.

As science progresses, so does our accumulation of both garbage and junk. America's seas and rivers and lakes become the resting places for most national refuse and our land takes second place. In time, our planet will become so packed with waste matter that we will probably have to send it to the moon or into space. In fact one government experimental project involves a program to do just that! Even now, there are several thousand tons of used–up rockets and man-made satellites orbiting overhead in space, all parts of our earth garbage.

Eagleville, Pennsylvania is just one of thousands of American communities endangered by mountains of garbage. Constantly covered with dirt, a five-hundred-foot elevation of waste matter towers above the landscape of private homes. The dumping project is termed a "landfill" but the poisonous seepage and foul odors have earned it less attractive names from local residents. Over half of our rivers are already poisonous from waste and their fish are dangerous to eat. Billions of toilets empty into rivers that will soon have to be recycled into drinkable water so what you now flush down the "john" may be what you will drink tomorrow.

Before the present day garbage age, it was actually fun being frugal. Just saving such things as nails, retrieving them and hammering them straight was a favorite rainy day pastime. Although early builders used wooden pegs as nails (called tree nails or trunnels) to fasten beams, nails were still used for flooring. Farmers were never wasteful and obsolete farmhouses were often burned just to reclaim nails. One Massachusetts farmer included an old house in his will "now in ruin, to be willed to ye Church and to be burned for its goode nayles and spikes."

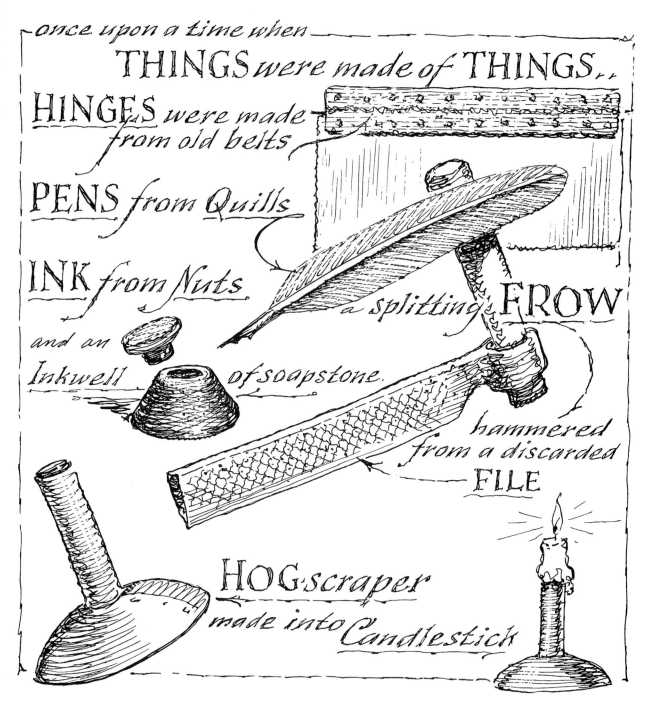

 The satisfaction of creating things instead of buying them must have been a miracle of joy for our ancestors. Imagine discovering your own ore (bog iron) as many farmers did, smelting it at home and then making your own hardware! Much of the American Revolution was won with handmade guns, hand-poured bullets and homemade gunpowder. Sulfur was mined in the hills; charcoal came

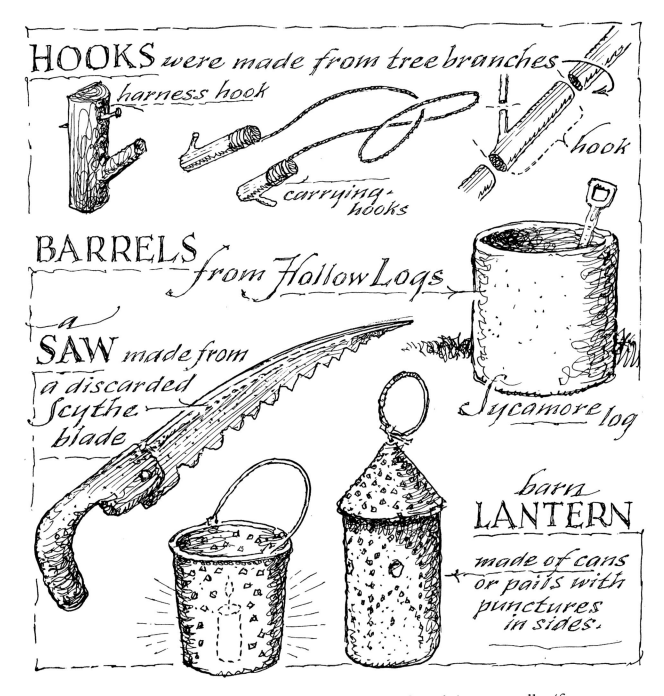

from hardwood; potassium nitrate was found in cowstalls (from animal waste). The army representatives went from farm to farm to buy these ingredients. Much later, as we all know, America became wasteful and sold scrap iron to a frugal enemy who fired it back at us in the form of shells and bombs.

Once upon a time many things were made out of other

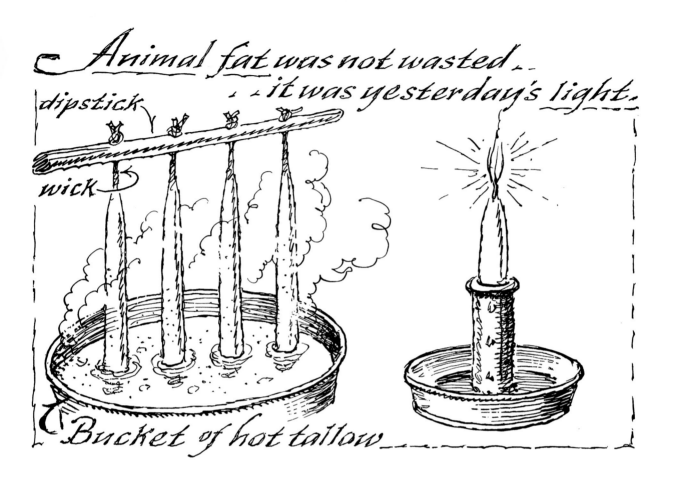

things. We see that sort of thing nowadays in the form of "kooky sculpture" conjured from scrap junk, but in the old days people were more practical. Old belts became useful door hinges, bits of broken mirror were saved and made into smaller mirrors, old walnuts were boiled down into a superior ink, and goose quills became fine pens. Old clothes became braided rugs, waste fat became candles, spoiled milk made the best paint and old plaster made fine garden fertilizer. Left-overs in the kitchen were never thrown away for there was always a large iron pot of soup in the fireplace which became differently flavored after each meal. Dishwater was poured over ashes and made into soap: old rags made a better grade of paper than we use nowadays. Nothing, once upon a time, was wasted.

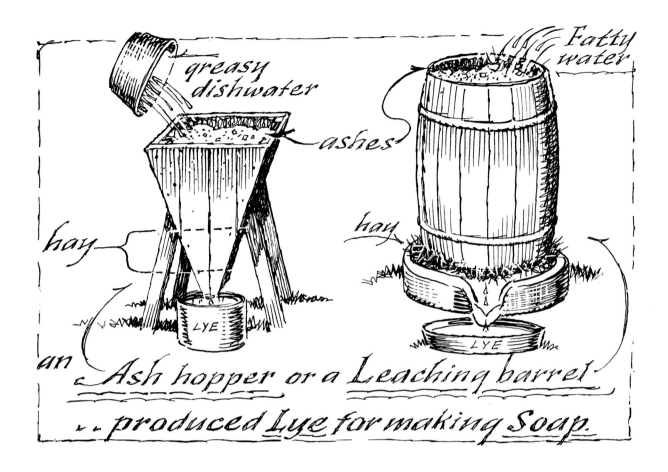

an Ash hopper or a Leaching barrel ... produced Lye for making Soap.

Today, many acres of a forest will be used in the daily edition of one newspaper. Most waste paper nowadays is dumped into the ocean, but when paper was made of rags it was never destroyed. Whatever notes you wrote or did in school or as homework, were kept and carefully sewed together into booklet form. The result, of course, was that even casual notes were done in a fine hand, knowing that they were to be saved. Recently a teacher made a test example, requesting her class to keep their lessons for a week and sew them into such old-fashioned booklets. The result was the best handwriting the class had ever done, for nothing had been scribbled carelessly and (through frugality) good writing was reborn.

Probably paper is wasted more than anything else today. Articles sealed in cartons are often resealed in plastic, then wrapped in another container. Needless wrappings are often worth more than the item itself. Then, of course, already wrapped items have to be carried away in a paper bag! Americans used to shop with market baskets, for the first paper bags were patented in 1859. It took a few years for these paper "pokes" to become popular but paper was still made of rags in those days and so you wouldn't dream of destroying a paper bag.

The disappearance of the American market basket as a shopping accessory has now made it a prize antique item; old baskets that once sold for a dollar or less, now bring amazingly high prices. European baskets were usually made of soft pliable reed and grass but the American basket was constructed of the hardest woods such as oak, ash and hickory. The process was unique. Cut at exactly the right time of year, hardwood slats were soaked for about a week in hot water, then hammered with wooden mallets until their wood fibres parted at their annual rings. This separated them into thin

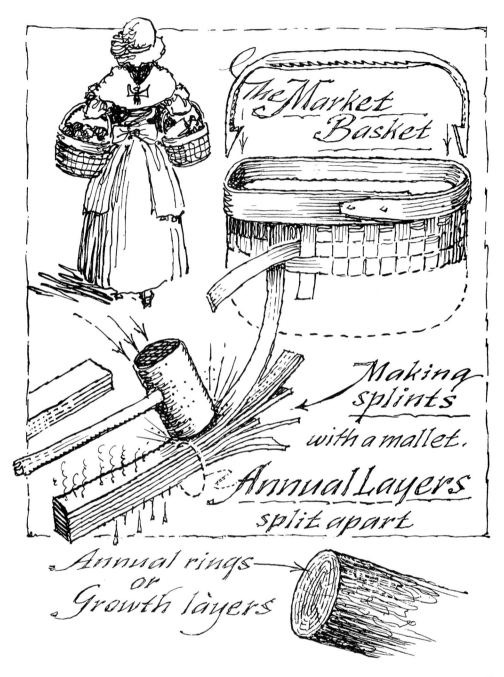

layers, and while still wet and hot these thin pliable layers were easily woven into baskets. When they became dry the wood returned to its original hardwood condition and the early American basket became a masterpiece of sturdy craftsmanship, passing from generation to generation.

Today when you use the words *life savings* you refer only to money, and when you say that a person *saves,* you mean that he has the cash to show for it. The rich man's will nowadays is the result of his saving money, but old time wills were almost comic in their listing of personal belongings saved during a lifetime and a cash legacy was rare. Haystacks, farm manure, pots and pans, axes, washtubs, tables and chairs, even firewood and jars of preserved fruits were the results of the deceased's own labor, accomplished for the precise purpose of saving and to pass on to the future. No wonder the old attics were full of such wonderful things, all hand-made legacies of the past.

In olden days one of the more fascinating rooms was the attic. The finest window of the old house was the fan-shaped "attic light." The word attic itself comes from the classic "Athenian" to describe architecture of extraordinary elegance and refinement. Not as today when attics are just storage space for cast off things, it used to be the historical museum of rare memorabilia where children on a rainy day could use it as a family library and enjoy their heritage. Ancient attics often contained articles more valuable than the whole house and land. The richest people of America were often penniless, but with no financial worries they were wealthy in spirit and purpose, with reverence for their past and confidence in the future.

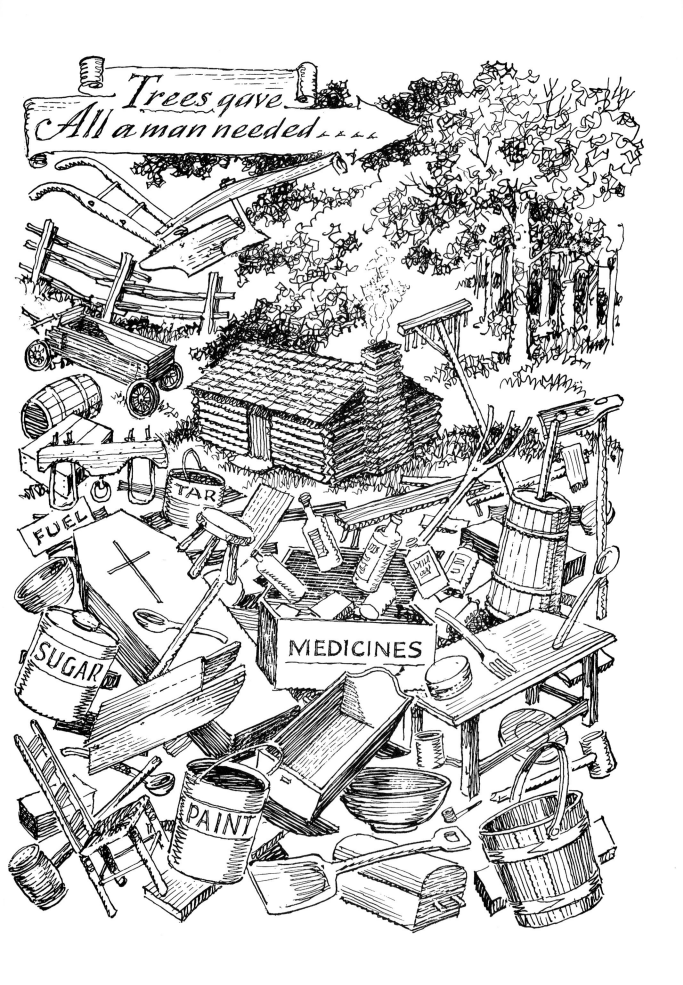

CHAPTER TWO

Once upon a time Americans had a Reverence for Wood

It is strange how few of us realize the importance of trees in our everyday life. Beginning with the fact that our very life depends upon oxygen (which trees afford us) while we breathe out nitrogen (which trees exchange with us), the forest might easily symbolize mankind itself. Once upon a time we were more aware and appreciative of God's gift and man had a mystic reverence for trees.

If it were not for trees, there could not possibly be the same America, for if it were not for trees, Columbus would not have arrived here: he like all other explorers, sailed in boats made of wood. If it were not for wood, America would not have specialized in manufacturing, for all water-mill wheels and mill machinery were constructed of wood. You might argue that in time they and everything else would have been made of metal anyway. Not so, because iron was smelted with charcoal (made from wood). In fact, the iron furnaces of New England once closed down and were abandoned

when that area ran out of trees for making charcoal. At the same time, however, coal was discovered in Pennsylvania and so the iron industry moved there, but the purity of charcoal-smelted iron could not be equalled by coal-smelting and to this day early steel has superior qualities.

The relationship between America and its trees is a peculiar and seldom realized one. The New World (according to most history books) was pioneered and settled in the cause of religious freedom, but the wealth of our forests at that time was the prime attraction, especially when England and Europe were experiencing a shortage of hardwood trees. Even before the Pilgrims landed at Plymouth Rock, there had been New York ships ferrying lumber across the Atlantic, and by the early 1700's special trees were being branded in New England with "the King's Broad Arrow" as material for His Majesty's fleet.

America's first export shipping business brought sassafras wood overseas. American sassafras tea was regarded as an extraordinary health drink, a tea that "prolonged life." One pioneer American businessman who made wooden-ware ("treenware" or items made of trees) claimed that drinking from a sassafras wood cup insured against most diseases and soon sassafras cups became prized household equipment in America. The only tree with three completely

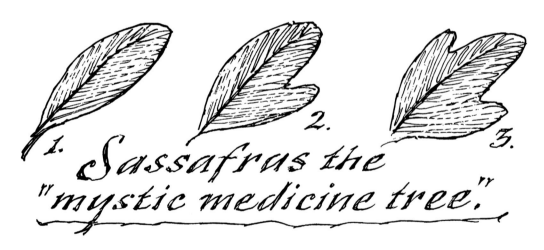

different leaves, the sassafras was considered mystic even among the American Indians who never used it as firewood and referred to it as the "sacred medicine tree."

In early days plagues were commonly spread by contaminated drinking water and so there were many American pioneers who drank only cider and beer. Even very young children were raised on apple cider or brandy rather than to risk childhood diseases with water. The apple tree became a national symbol; in some places in New England it was against the law to destroy fruit-bearing trees. Apples were dried, candied, creamed, roasted, cidered, sauced, buttered, brandied and made into all sorts of cakes and pies. It was even used as a medicine and an apple a day usually did "keep the doctor away." Apple butter became a national staple, made each autumn in great iron pots and put up to last throughout the whole winter. Special apples were picked with cotton gloves, laid carefully in salt hay, then hung by their stems with string so that they might last longer. There were root cellars whose ceilings were festooned with them, and apples stored in that manner have been known to keep for two years.

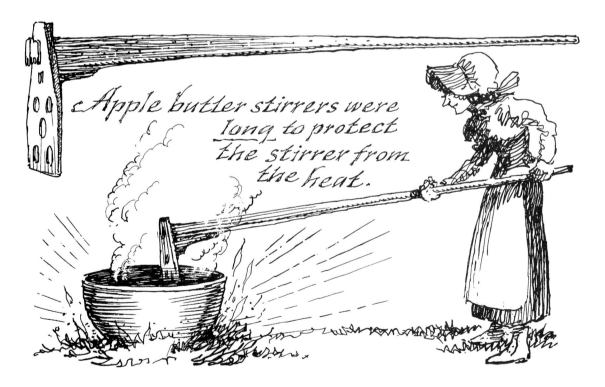

Apple butter stirrers were long to protect the stirrer from the heat.

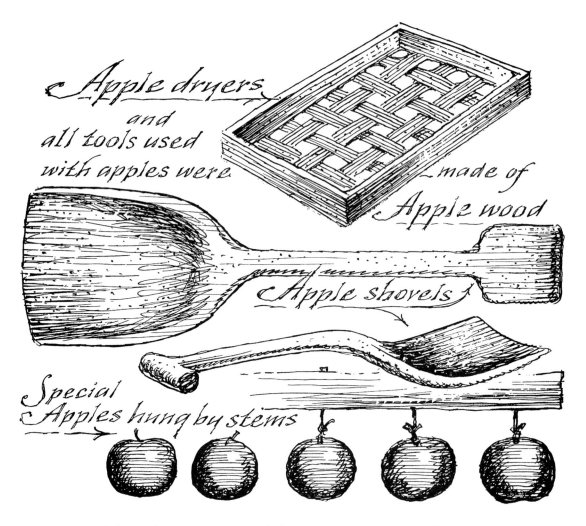

Apple dryers and all tools used with apples were made of Apple wood

Apple shovels

Special Apples hung by stems

Nowadays commercial farmers grow only a few kinds of apples, only those that are of strong texture that can be shipped by rail or truck without bruising or spoiling. Once there were over a hundred well–known kinds of apples, each with a special fragrance, shape and use but now we know only such hardy apples as the Delicious, McIntosh or Northern Spy. It is easy to understand how this tree which produced cider and brandy, butter and dessert and many other important needs of the day, had a special place in the pioneers' reverence for trees.

The first American flags had trees in their design, as did our money (the pine tree shilling and oak-decorated bills) and the first

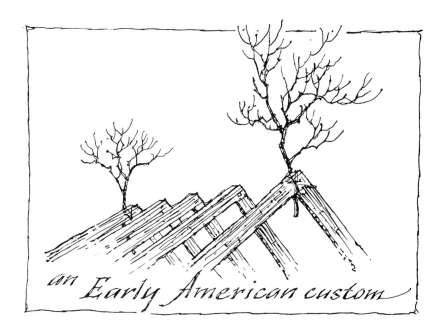
an Early American custom

signings of American charters and village declarations were usually enacted under some significant tree such as a "proclamation pine" or "charter oak." The first American log houses were blessed in a ceremony and when the last rafters were put in place, the jubilant builders decorated the peak with a symbolic tree. This custom has survived in New England where modern workmen still tack a sapling on a new roof and expect a "drink break" to celebrate that event.

Trees were even involved in early American marriages: it was a New England custom to plant two trees at the entrance of the new home, known as "husband-and-wife trees." When land was cleared

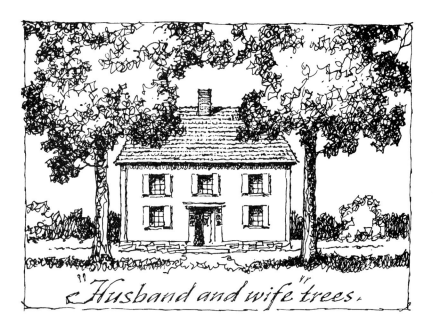
"Husband and wife" trees.

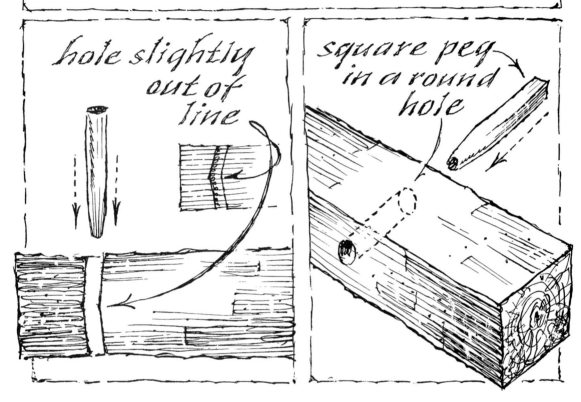

and surrounding forests in New England were almost denuded by the need of charcoal to feed iron furnaces, there were some places in Connecticut where only husband-and-wife trees remained on the landscape. Those trees still mark the location of many old farmhouses.

Some antiquarians explain the great use of wood in early days as resulting from a shortage of metal, but there was much more to it than that. The old–time reverence for trees involved a profound knowledge of wood which is now a nearly lost knowledge. Every schoolboy knew the names of all American trees and was familiar with the exact qualities of each wood. A sled or carriage, for example, would be made of several kinds of trees, each wood having a

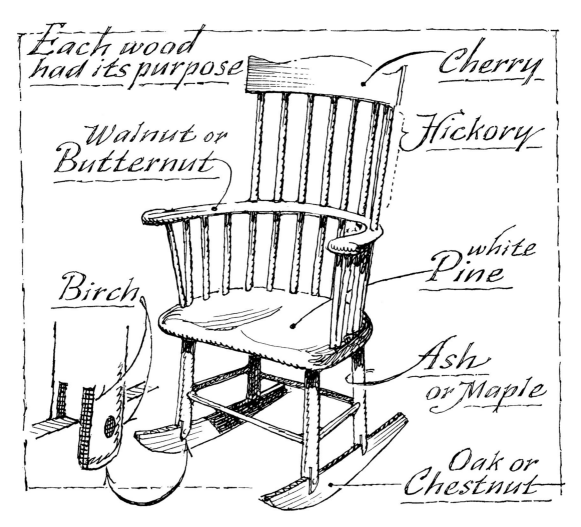

particular purpose. A simple chair might involve seven kinds of wood, each having its own reason, with one wood acting against the other to keep the joints tight and strong in spite of changing weather. That is why there are so many antique chairs still existing in good shape, without cracks, wearing or even squeaking.

Nails were seldom used, not because of a scarcity of iron but because driven metal usually results in splitting the wood. Trunnels (tree-nails) or wooden pegs became part of framing, giving and taking gracefully with each weather change. No early builder would think of using metal nails to put a house together; instead he chose the proper wood for pegs that favor the kind of wood used in that particular frame. In time, the beams and their fastening pegs would

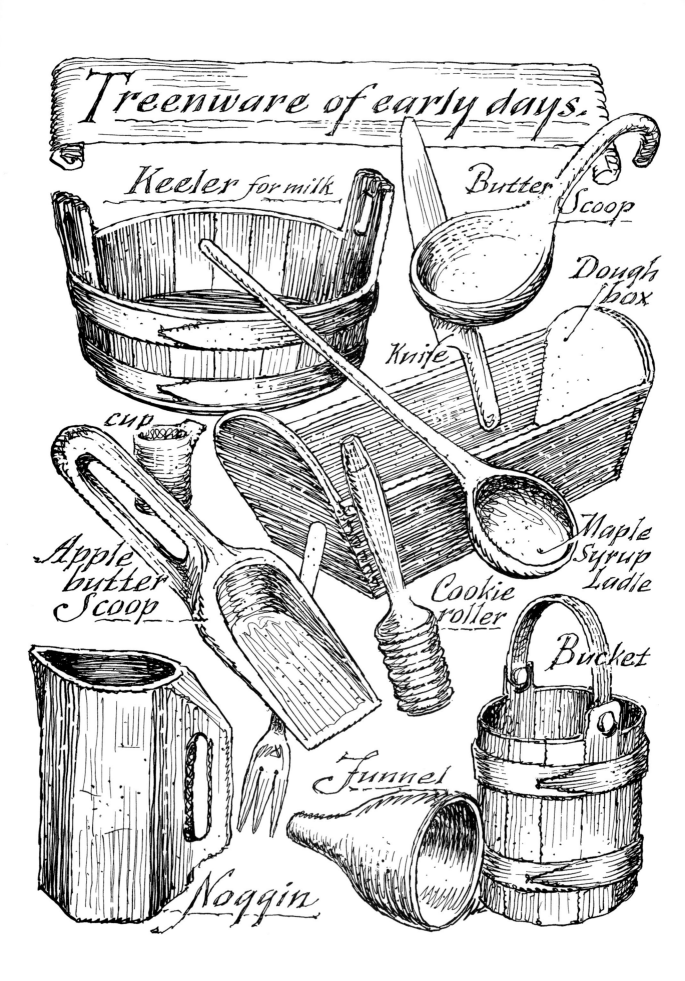

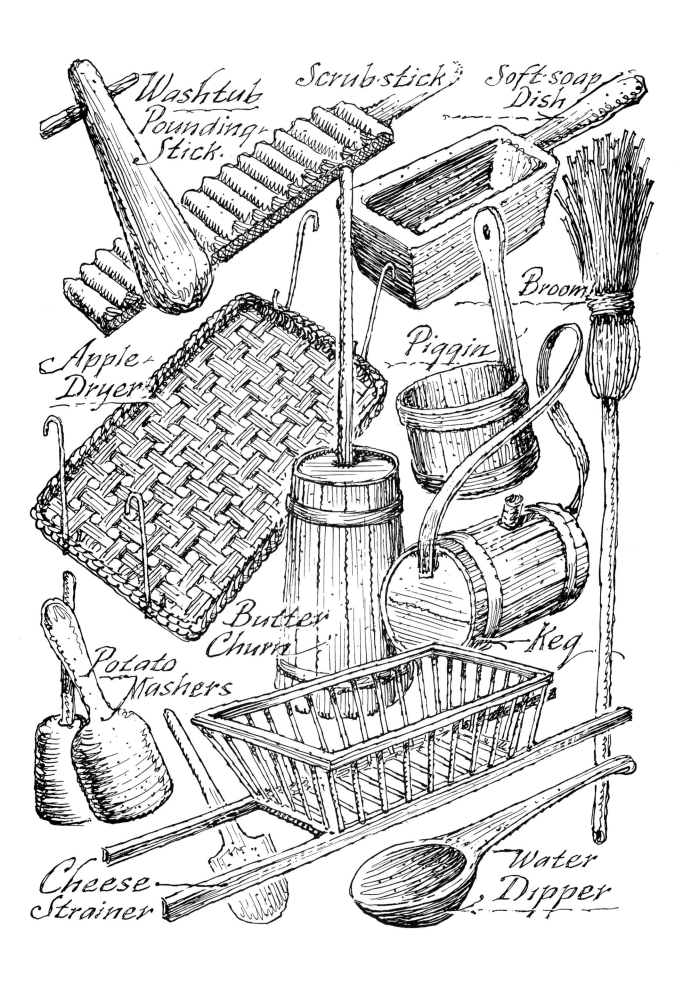

exude sap and weld themselves together, always breathing with the changes of weather and without splitting. Pegs were often driven into their holes at a slight angle, or a squarish peg was driven into a round hole so that the squeezed peg soon became an integral part of the framework, something a nail of course, could not do.

Where water is involved, wood actually outlasts iron. Sunken anchors will in time rust and decompose while the actual wooden vessel still remains intact. Recently when some modern iron sewer pipes had rusted and fallen apart in New York City, digging disclosed wooden sewer pipes that had been put in place nearly three hundred years ago; the wood was still in serviceable shape while the newer iron pipes had rotted away.

The American pioneer needed little other than his axe, for here in a wonderland of forests was all the material that any human being needed. From cradle to coffin, the house with its logs, its floor and roof and all furniture, were made of wood. Sugar (from maple), tar (from pine), medicines and paint, sleds, boats and wagons, dishes and bowls all came from wood cut in the forest. Even the school blackboard was exactly that, a wide smooth pine board painted with flat black paint. You hear of tinware and ironware but one of the lost words of yesterday's language is "treenware" (articles made of wood). With the help of an axe and a knife, most pioneer boys became expert at manufacturing household treenware and were known as treensmiths.

Of course, trees also afforded fuel for heating and cooking. Wood was plentiful, yet in the beginning people were careful not to waste wood, cutting down only certain hardwood trees for fuel and special softwoods for kindling. There was a law against destroying fruit trees and rented farms often allowed only fallen trees and dead branches to be used as firewood. "Only that wood which may be taken by a *hook* or a *crook,* may be taken for fuel," was a stock phrase in early rental contracts. We no longer use "hooks or crooks" but that phrase still persists in modern American slang.

Today, beet and cane sugar has become a devastating American habit; it is quite impossible to find a commercial or canned food of any kind that does not contain it. In a lifetime the average American eats three tons of sugar. Sugar injures the heart, causes overweight, decays teeth and creates diabetes, yet once upon a time it had no place at all in the American diet. When sweetening was confined to honey and maple syrup, the American was indeed a healthier being.

Although it is nearly impossible to find anything completely American, it might be only maple syrup which was introduced by the American Indian, made only from the American maple tree. Thomas Jefferson, in a letter written in 1797, said: ". . . I am led to expect that a material part of the general happiness which Heaven seems to have prepared for mankind, will be derived from the man-

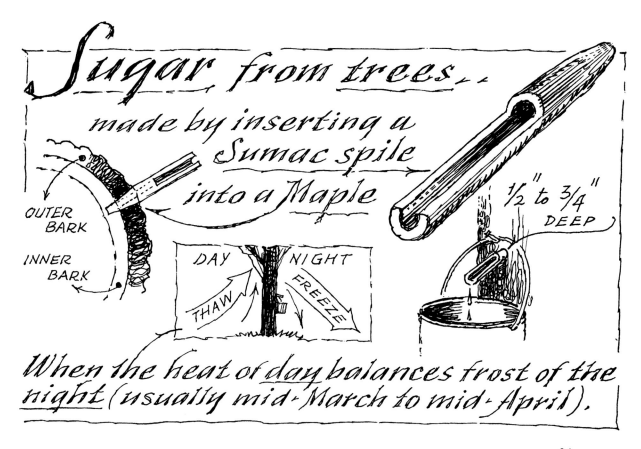

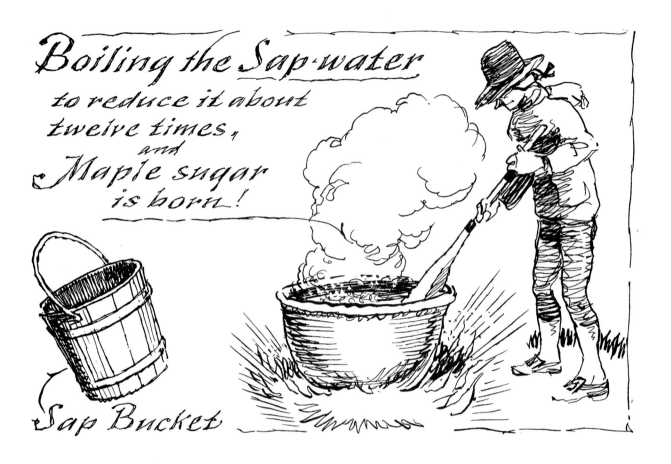

ufacture and general use of Maple Sugar." He had not foreseen the easier ways of making sugar but he certainly did predict the American sweet tooth.

Between the middle of February and the first of May, the sap runs in maple trees when there is frost at night and thaw during the day. This magic combination sets maple sap to flowing and ready to tap. The temperature must not rise above 40 degrees by day nor go below 24 degrees at night. A hole is made in the tree (from ¾" to 2 inches deep) using a half-inch auger bit. Then insert a spout or "spile" for the sap to flow from and you are in business. The sap flows out as a sweet water but when reduced (by boiling) about twelve times and left to settle, it becomes virgin syrup. You will have made at no cost, sweetening worthy of the table of the gods.

It is easy to understand how important the tree is to mankind and why the early American recognized it as the real wealth of America. We should still recognize the value of wood. The book you are reading is made of wood (paper) and the money you bought it with was wood (a check). You blow your nose on wood (Kleenex) and clean yourself with wood (bathroom tissue). News is printed on wood (newspapers), milk and food arrives in wood (cartons); and so all through our space age, we are still dependent on trees.

Today we are again learning the economy of growing trees for fuel as our oil supplies grow inadequate. Oil and coal (if we contemplate their origin) are actually the results of the petrified forests of prehistoric ages, so in one way or another, whether in oil furnaces or gasoline-powered automobiles, we are still using the energy of *trees*. We may run out of oil in time, but a tiny woodlot can grow to fuel proportion in only a few years (which cannot be said of oil). Wood energy can be produced over and over, forever and ever. Or it can be wasted and become extinct.

The once-upon-a-time reverence for wood is understanable, but forests are still a major asset and we could hardly do a more meaningful and patriotic act today then to plant trees. Pioneers were doing that sort of thing religiously long before ecology became a household word.

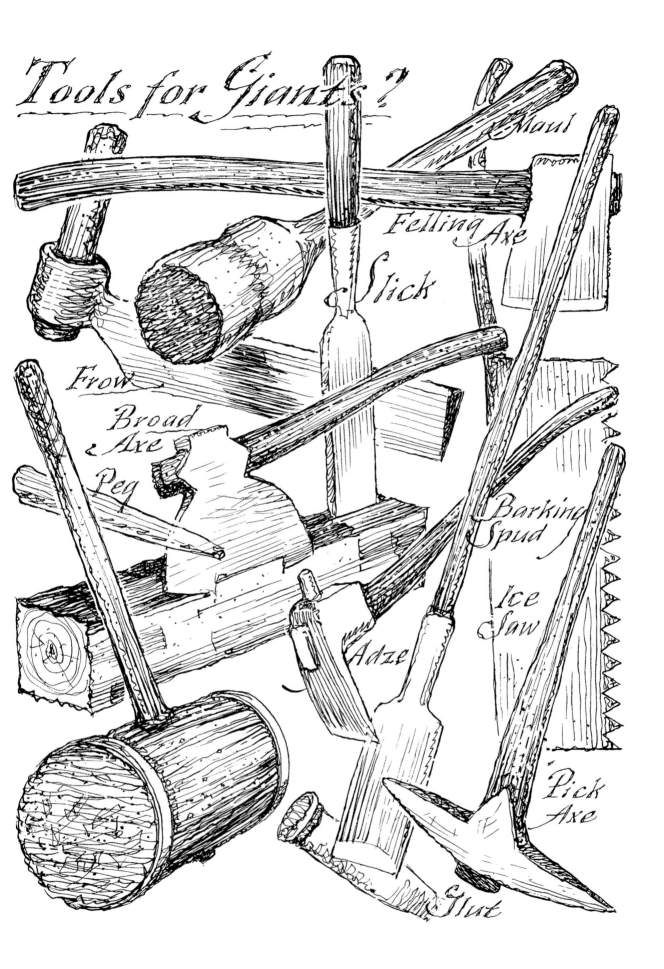

CHAPTER THREE

Once upon a time Americans enjoyed Hard Work.

When you see early American farm implements you are instantly impressed by their great size and weight, seemingly too heavy for anyone to really use. When you behold the remains of old farmsteads with their ton-sized rocks, beams much heavier than you can buy today and endless fences of gigantic rocks, you tend to believe the old timers had to be giants. However the little-known fact is that the average man of yesterday was much smaller than the man of today. The bunks of the old whaling vessels look as though they were designed for children and antique top hats seem to be designed for midgets. The death masks of our early presidents are like miniatures of the great men we might imagine.

Kit Carson, Daniel Boone and most of the early pioneers were remarkably small, some you could even call tiny but they were bundles of alertness and energy and strength. They were rather like the bread they ate which was hard and heavy, small loaves but full of rich substance. Nowadays most bread is puffed, large in size but far

from the coarse-ground corn bread that used to be called the "staff of life." There were no fluffy loaves of bread once upon a time and there were no flabby farmers.

It seems inconceivable that hard work could have been a pleasure but such was the case two hundred years ago. It is understandable that men can be proud of their strength and that doing a difficult job can bring great personal satisfaction. There was something brave, something Robinson Crusoe, about single-handedly carving out a homestead in untouched forests and making it liveable with your own two hands. It was a joy that few or none of us are allowed to experience nowadays. Hard work has become a sort of punishment or at least something to be avoided: workers' unions concentrate upon ways for the laborer to work the least for the most wages. Workers, however, used to feel a satisfaction in working an extra few minutes after quitting time just as the baker used to sell thirteen rolls and call it a "baker's dozen."

Once upon a time when there were no power machines on the farm, men learned how to do things the easiest way, rather like the professional weight-lifter who learns *how* to lift and *how* to use his muscles. With a shoulder yoke for example, children and women carried two buckets full of water with more ease than one bucket could be carried. A wagonload of beams or rocks that only a team of oxen could move, could be put on a sled and pushed over ice by the strength of a small child. Where wagon wheels would have sunk and mired in the old roads, all heavy loads were therefore waited until winter and moved about by sled. Even during summer, granite was sledded out of quarries on greased runners and much of the heavier loads around the farm were slid over grass rather than using wagons. Actually the art of sliding was practiced in more ancient days for such work as building the Egyptian pyramids. This art can be appreciated when you want to move a heavy piece of furniture or a large refrigerator; by resting it on an ordinary broom, a child can pull it from room to room with very little effort.

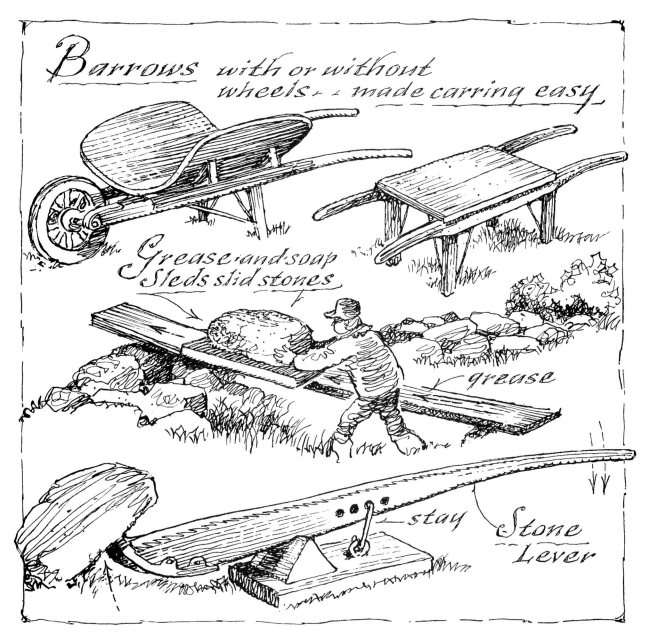

Sliding was so important once upon a time that for every wagon on the farm there were several sleds. The art was so important that winter was the time for moving all loads of timber and stone, and much of the toll income over the old covered bridges was sled traffic. Although many people think that the roof on the bridge was to keep off snow, you can realize why bridge owners had to shovel snow into covered bridges or sled traffic would have come to a complete halt.

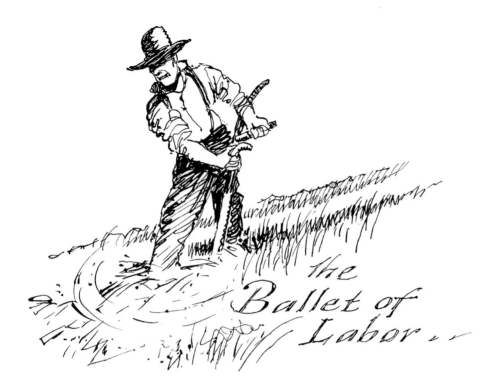

The Ballet of Labor

Another secret of accomplishing tedious work the easiest way was the studied method that farmers used to attack their chores. Often seeming to be slow and "dragging their feet," the old timers were getting more work done than most farm workers do now in their hurried way. Watching a team of fifteen or twenty hay mowers in a field was like witnessing a slow motion ballet. Starting at sunrise and with few stops, the scythes were swung in unison but in a casual manner to avoid tiring the operators. By sundown the pace would not have slackened. "Taking it easy," said Benjamin Franklin, "is the fastest way to do the most work." The simple farmer said it even better: "The fastest grown pumpkin always turns out to be the poorest."

Vacations from work used to be seasonal affairs but now they are spread out for the benefit of the worker. The old–time farmer had only one day of rest but now there is usually a Saturday added to the workless weekend. That makes a hundred and four days of rest,

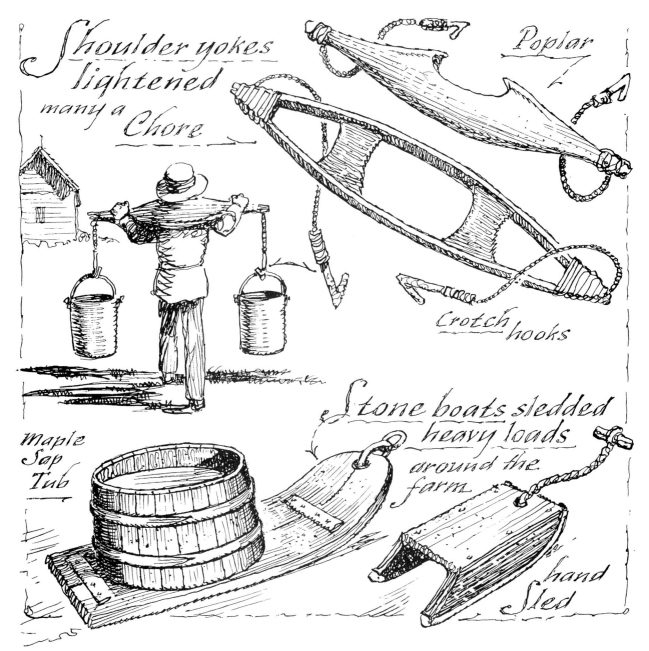

leaving two hundred and thirteen days for work. But no—there are about twenty religious and patriotic holidays and that leaves only a hundred and eighty-three days (less than half the year). And there is still a vacation expected. The old–time farmer who had to milk and do daily chores every day of the year would have a hard time believing a work year could be about one hundred and fifty days.

In a recent poll of students run by the University of Connect-

icut, Americans stated that "fun and enjoyment is more important and more desirable than work, and shirking from labor is no sign of laziness." It is interesting to note that such rules do not apply to sports for the greatest athletes are always the hardest working ones and there is little or no argument about that. Hard work is part of the sports picture and the only human effort left it seems, where man enjoys the satisfaction of hard labor. The cornerstone of one early American schoolhouse said it nicely: Life's enjoyment is life's employment.

Love for work used to be a valuable asset, something taught and then handed down from generation to generation, just as the tools of a man's trade were inherited. Nowadays when a carpenter or plumber or farmer dies, his tools usually die with him, appearing in a garage sale or cast away as things of the past. But once upon a time children were more inspired by their parents' lives and therefore were more apt to follow in their footsteps. The old-time carpenter's tool chest seldom contained new implements but was filled with ancestral prizes. When you find early American tools in antique shops there will usually be initials and sometimes the date they were made: this was not to identify them in case of robbery but to identify them as part of the craftsman's life and for the purpose of heritage to a future generation. The old designs never changed because they believed a good thing was worth preserving.

It is inconceivable that anyone who loves his work would look forward to retirement from that work; so the fact that most people nowadays look forward to retirement, proves that most people work at something they do not enjoy. It is also a fact that work lengthens lifespan and most natural deaths occur a short time after retirement.

Once upon a time people did not work "to make a living" as much as we do now, but strange as it sounds to the modern ear, they worked because they loved their work. Charles M. Schwab, one of the last old-time tycoons wrote about his life, "The man who does

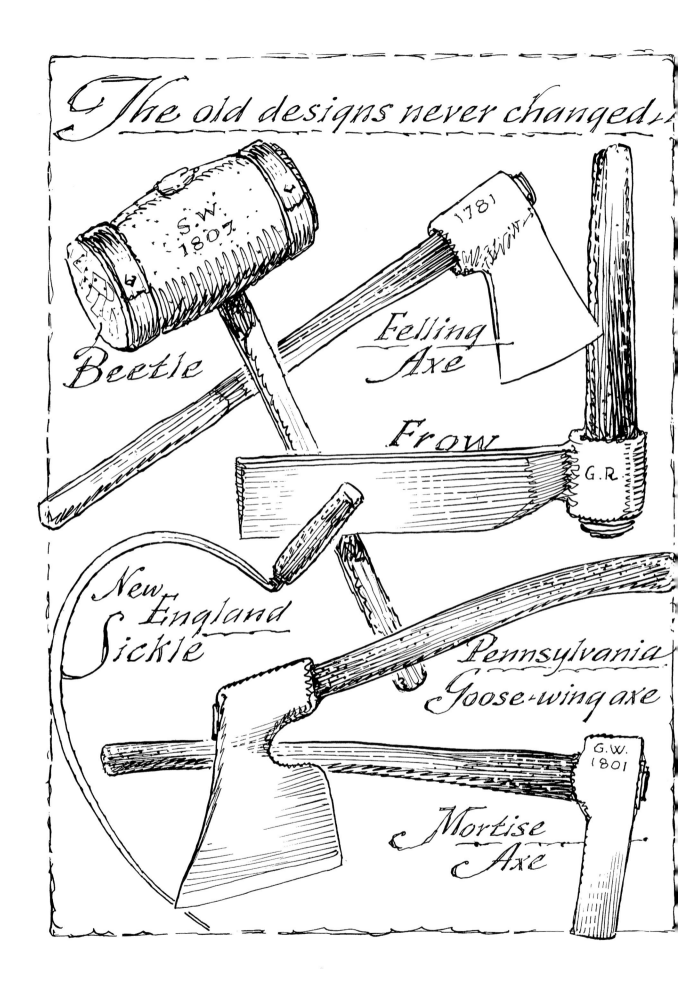

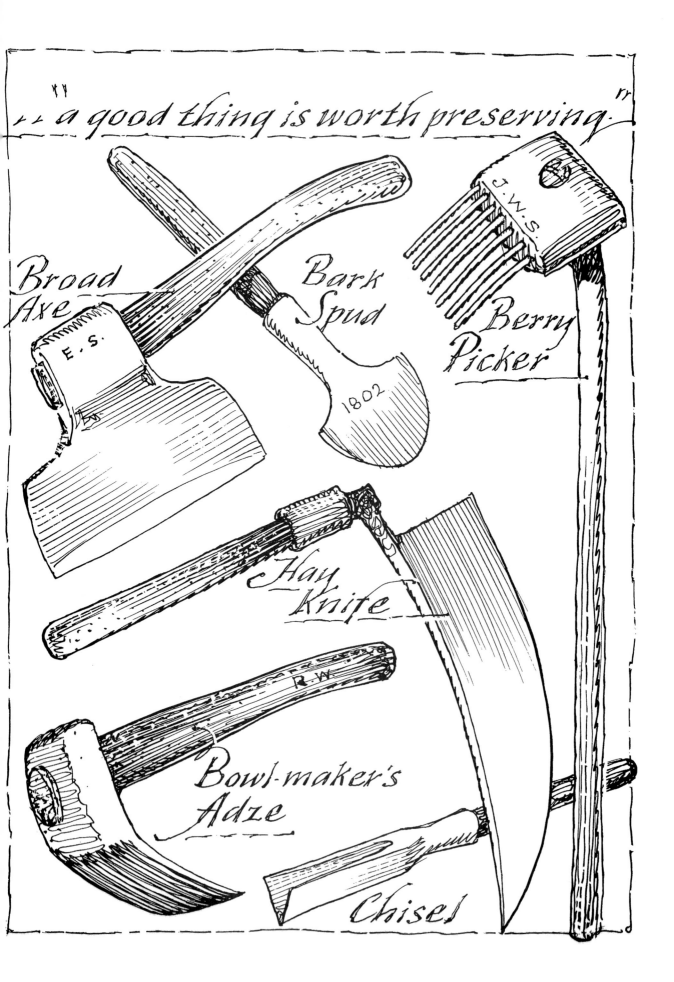

not work for the love of work," he said, "but only for money is not likely to make money nor to find much fun in life."

Today men work hoping to amass a fortune; if they are successful they can retire and admire their bankbooks. But once upon a time when the homesteader was too old to work, he could remember the land when he first found it and look out over the fields and stone walls, the barns and all the things that were the results of his labor, and feel true satisfaction of life's enjoyment.

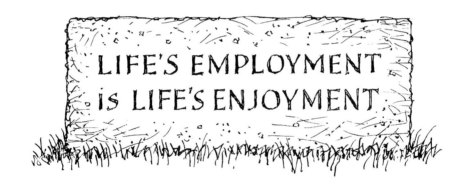

CHAPTER FOUR

Once upon a time the American Home was more than an Address.

1682

1982

The early American house always started with a definite shape and that shape was then divided into separate rooms; as the family grew, rooms were partitioned off into smaller rooms. Today we group together what rooms are needed, then cover the grouping with one irregular roof: the result is often an indefinitely shaped house of roaming proportions. Heating such a group of rooms is difficult; the early saltbox, however, was a compact fort against enemy winter. There was a gigantic central chimney with all fireplaces stemming outward. Leaving downstairs doors open allowed the heat to rise and help warm the upstairs. The chimney topped the old house like a crown, often a work of art. Nowadays chimneys are tacked on wherever an oil burner or a stove happens to be.

Once upon a time houses had unique character. That may sound foolish and the reader might contest such a statement, saying that modern architects are still designing houses with character, or that they are still designing replicas of the old designs. Yet when night falls and houses are outlined against the sky, the really old houses stand out boldly and an expert can pick them out easily.

The building of a home or farmstead that would accommodate your family for generations to come, was once a profound personal lifetime purpose. Without purpose we have less reason for being on earth, yet if you ask people today what their life purpose is, few can come up with an immediate or sensible answer. Most think that we are here to "become a success" and some people spell it succe$$.

Purpose is something usually born in the home and without purpose, life becomes like a lost dog running in circles. I recall while travelling, picking up a young hitch-hiker and offering to transport him as far west as my destination. On my way home, however, I encountered the same fellow heading in the opposite direction. "Where are you going now?" I asked him. "No particular place," he replied. "I just like to travel. There isn't anything interesting to do at home." Indeed houses and homes have changed and the architecture of our lives has been affected.

There is an old saying that home is where the heart is, but the older (and original spelling) was . . . "where the *hearth* is," for the hearth was once the heart of the home, where a fire burned continually and year round. The soup pot was started in autumn and it never cooled during the entire winter; each day something was added, becoming a different taste. The English oven (misnamed "Dutch oven") in the brick wall of the fireplace, was seldom without something baking inside. The true Dutch oven was either a tin reflector-oven that faced the fire or an iron pot with space for coals in the lid. In summer, fireplace cooking made the kitchen unbearably hot, so

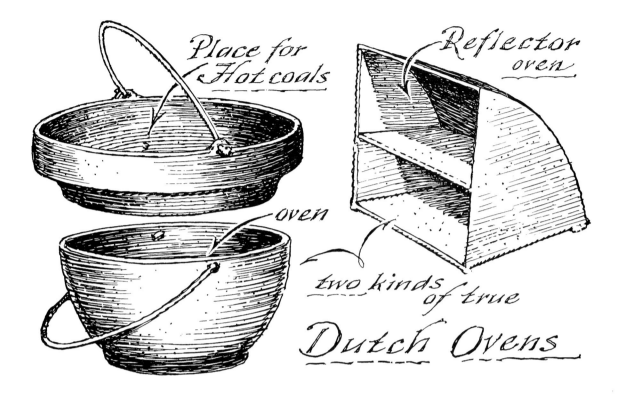

there was often an added wing to the north known as the summer kitchen, attached to the main house by a breezeway.

With herbs hung from the ceiling, apple slices drying in hanging baskets and bread being baked, there was a constant perfume of rich living in the old-time family kitchen. And it was the hospitable gathering-place for the whole family, a far cry from the stand-up counters and pristine plastic coldness of today's stark kitchen. One sampler sewn by a little girl in 1810 said it well:

> *Pictures other rooms adorn*
> *But in the kitchen, home is born.*

In the ceiling around all ancient kitchen fireplaces, you would see iron hooks that are usually regarded now as hooks for hanging

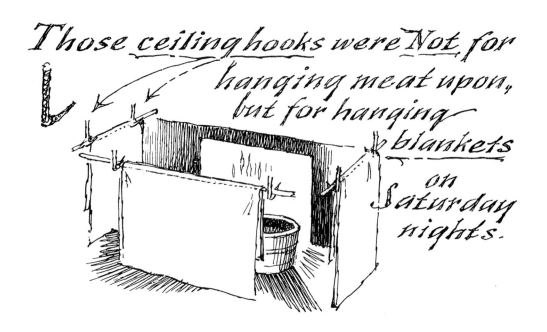

meat to dry, but you'd be banging your head on the meat! Actually they were for poles to hang blankets on, forming a fireplace tent that formed a heated bathroom. A tub of hot water was placed on the hearth and with heat and light from the fire, the Saturday night bath was always a comfortable kitchen fireplace occasion, made private by the enclosure of blankets.

The layout of early saltbox farmhouses was traditional: the kitchen was always protected by a great slope of roof toward the north with giant shingles (called "shakes") added to clapboards for added insulation. The opposite side of the house faced south to be warmed by the winter sun. Like barns, all early buildings were placed weatherwise and not situated according to streets or roads (as houses are built today). Solar heating really began a long while ago, once upon a time in early America.

Once upon a time houses were lived in more than they are now. That sounds ridiculous, yet most of us spend time a distance from home, commuting or going to school, making as much as an hour or two round trip by car or bus daily. The average commuter spends as much as a hundred (eight hour) days annually sitting in a vehicle. We also dine out away from home more than we used to. We go away from the home to be entertained and we use our home primarily as a sleeping place.

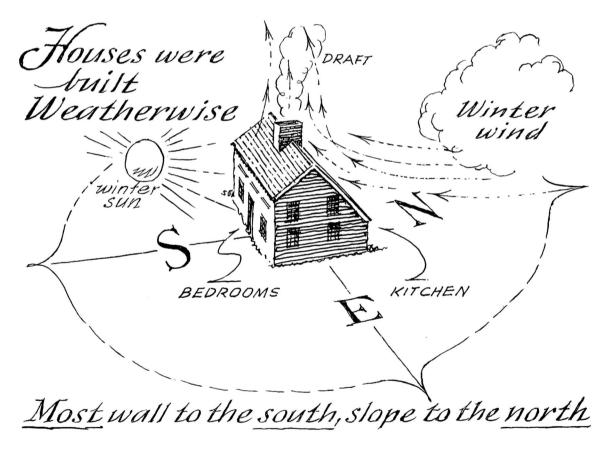

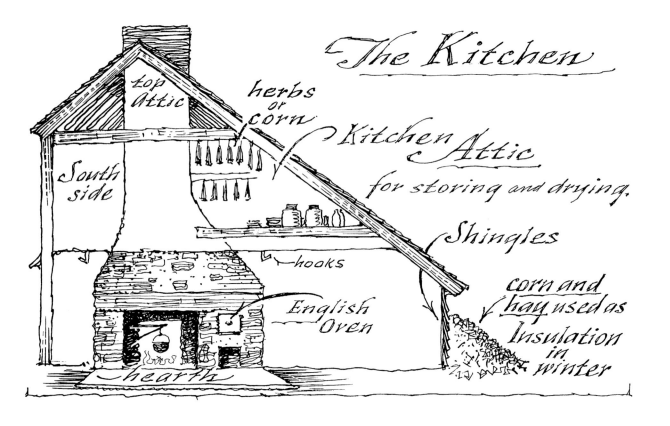

It is interesting to note that the early American never went out after sundown for dinner: supper was "supped" in the bedroom and it consisted of broth, tea or some other kind of liquid food. Actually going to sleep on a full stomach is unhealthy and most fattening, so the old time supper was an excellent habit. As houses were usually far apart and there were no lights to travel by, you may see why night-time parties were all but impossible and why dinner guests were always entertained before the sun set.

Home has sadly become a temporary part of life. Once upon a time men built for future generations instead of creating an address for the moment. Most people today will have lived at over twenty addresses during a lifetime while a century or two ago many died at the same place where they were born. Building material is also temporary, most all building wood being soft pine which is used for "balloon-framing" instead of hardwood beams for "skeleton-framing." The first balloon-frame buildings were barn silos (built at the turn of the century) for they have no skeleton framework to hold them up. You will see barns of the late 1800's still erect with their massive oak skeletons, while the adjoining silos are all leaning, due to their *lack* of skeletons.

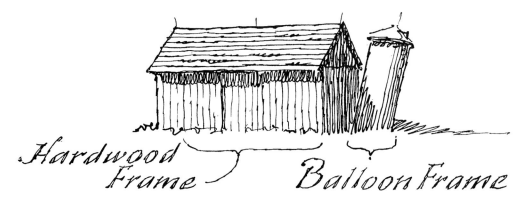

Hardwood Frame — Balloon Frame

CHAPTER FIVE

Once upon a time Americans were close to Nature.

It seems impossible that all Americans were once farmers, but when you think about it, even owning a horse made you a farmer because then you had to raise the hay to feed the animal. If you were a lawyer, doctor, blacksmith or office worker in pioneer days, you still needed a piece of land that grew grain and feed for your horses and livestock. Even George Washington was a farmer and so were all the other fathers of this country whether they rode horseback or went about by carriage. All of them were farmers.

Now of course, we do not travel by horse, and all farming is a career done far away from the city, conducted as a business. In the beginning when farming was a family pursuit, farmers raised crops only for themselves and their own families and not to sell on the open market. Farming, once upon a time, was not a career or a way of earning money; instead it was a personal *way of life*.

In the 1700's, the highest and most exalted pursuit of man

(next to preaching the gospel) was the practice of farming (but even the preacher in those times, had to be a farmer). Gradually as the industrial revolution approached, and the farmer's sons left the farm to earn money in cities, the farmer, without help, became poor and isolated. He was soon regarded as a second rate citizen, and ridiculed as a country "hick," with nicknames like Reuben or Ezra. Nowadays only a few scattered family farms exist. Where once everyone was a farmer, and later there was about one farmer for every hundred people, now there is probably only one farmer for every ten thousand people. We have become so isolated from nature that there are only a few special shops, known as "nature food stores" or "health stores," selling simple kinds of farm food that Americans once ate.

Once upon a time knowing nature added spice and joy to everyday life. The average farm child knew more about nature, the universe and the heavens than does the average city child of today, in spite of modern scientific knowledge. For example, although man has now reached and walked on the moon, the average person seems to know less about the moon than he did two hundred years ago. Ask anyone now, what is the general direction of the moon's path, how often it appears full, or how many hours does a full moon illuminate the sky: few can come up with an answer. Yet two centuries ago, all cross-country travelling and droving had to be done during moonlight, and many farm chores were done at night. Moon lore was an important part of the farmer's almanac and everyone was familiar with lunar activities. There was less superstition about moon lore than is supposed.

Nature provided almost everything that pioneer man needed; it even offered to run all of our factories by the use of free wind and water power. When mined coal and drilled oil entered the scene, and later when electricity seemed the quicker and better way (in spite of greater cost) natural energy quickly lost favor to the speed of modern

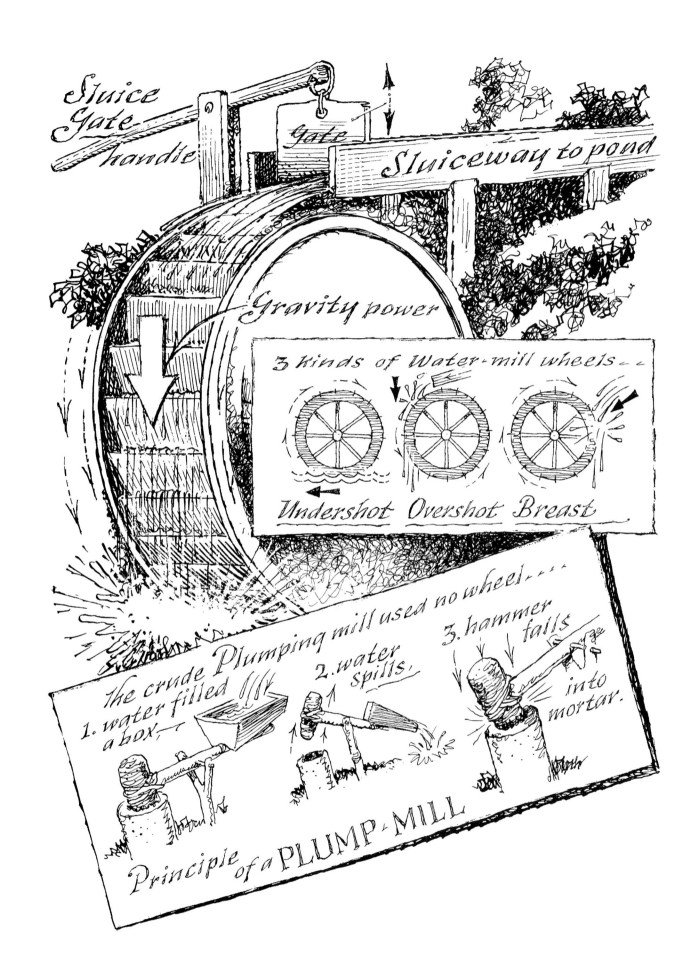

machinery. It could just be possible that after depleting all of our coal and oil, we might some day have to go back to nature, to resume taking advantage of free water and free wind, as we did so successfully once upon a time.

Most people presume that water-powered mills need tons of rushing water, yet a small stream can cause a wheel of many tons to turn and move the heaviest of machinery. This is done by the use of early America's favorite power wheel called the *overshot* wheel, where water's weight is used but *gravity* is the actual power. A small stream (or spring) fills a millpond, and when power is needed, a sluiceway feeds the *weight* of water to the top of a wheel. That weight starts the wheel in motion which continues to turn as long as water is fed to it. It seems strange that so small a bit of water can be so powerful, but within the confines of an old mill, the awesome power was evident by the shuddering of the great beams and the sound of the giant wheel groaning in motion, a few gallons of water turning many tons of machinery.

The *undershot wheel* simply sat in a moving stream or river and had less power because it used only the speed of water rather than the weight. The *breast wheel* utilized the power of force as the water hit the wheel amidships.

Nature's gravity was also used in the early *plumping mill,* which small boys often built, needing no wheel whatsoever. This was just a small water-powered mill that slowly filled a box, which emptied by gravity, enabling a stone hammer to rise and fall to pound cornmeal into flour. Gravity is one of nature's most powerful forces, an energy that, of course, shall never give out.

In the city if access to food or heat ceases for only a few hours or days, there is chaos, and we might think that God has not been as good a provider as we had thought; but cities were built by man, not designed by the Creator. In rural country where wood is always available and wind and water are plentiful, and food can be grown

and stored for emergencies, you begin to realize how well nature had provided for man. Once upon a time America was aware of God's providence but today in the metropolis, God's providence is not as evident and we easily overlook it.

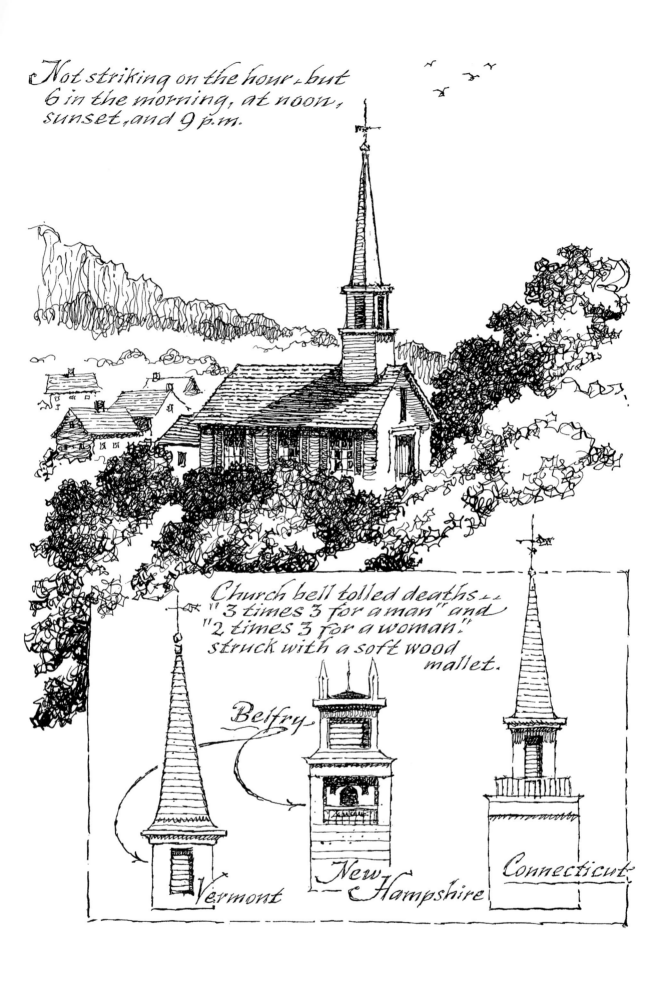

CHAPTER SIX

Once upon a time all Americans trusted in God

 Designed as slender fingers pointing toward heaven, few symbols of America's past are as profound and meaningful as the ancient church spires of New England. In each belfry, church bells capable of sounding messages for a distance of over two miles gave coded news of births and deaths, announced fires, town meetings and church services. Sunrise and sunset, holiday greetings and even a call to arms during wartime, church bells were the radio of early days. Belief in a Creator and respect for God was a most important part of the American way, but the church was evident in all the chores and callings of daily American life.

 With all of our present day riches and architectural progress, we seem unable to afford to build proper church steeples. You will see tiny apologies (even mail-order stock plastic ones) available for adding to the roofs of modern buildings in a sad effort to copy the lofty spires that the churches of America used to display. Perhaps the

outside architectural style reflects what goes on inside, for the attendance and spirit of modern religion is also a tiny apology for the moving force it used to be.

Nowadays when there are organizations trying to remove the mention of God from American currency and when prayers are being forbidden in most schools, we have come a long way from the original concept of America. When our nation was formed, the phrase "In God We Trust" was a grave national commitment, and so we must believe that democracy without that commitment becomes a departure from the original concept. Belief in God must not be a waning American heritage.

The church building once played an enormous part in early American life. In the beginning, it was called a meeting house and although a house of God on Sunday, it was the town hall and common meeting place all during the week. The preacher was often schoolteacher when the Sabbath day was over, and because books were scarce in those days, the Bible became a common American school book. Writing exercises were often quotes from the scriptures, and prayers were part of the daily lesson in penmanship and English.

On Sunday, all business ceased and "braking the Sabbath" was punished by a stiff fine. Tolls through the old covered bridges were eliminated on Sunday so that people could go to and from church freely. Even stagecoach and carriage traffic ceased unless it was for church traffic.

Observing the early American Sunday was not the token trip to church that it is today; it started at sundown on Saturday and lasted through a rigid day of prayers and thanksgiving, ending at sundown on Sunday. Church for some, meant a long trip by carriage or sled with the whole family, including children. You brought along your own dinner and even your own heat. Coals were carried in little wooden boxes, because the early churches were without fireplaces or stoves. There was an adjoining cabin called a "sabbady house" (Sab-

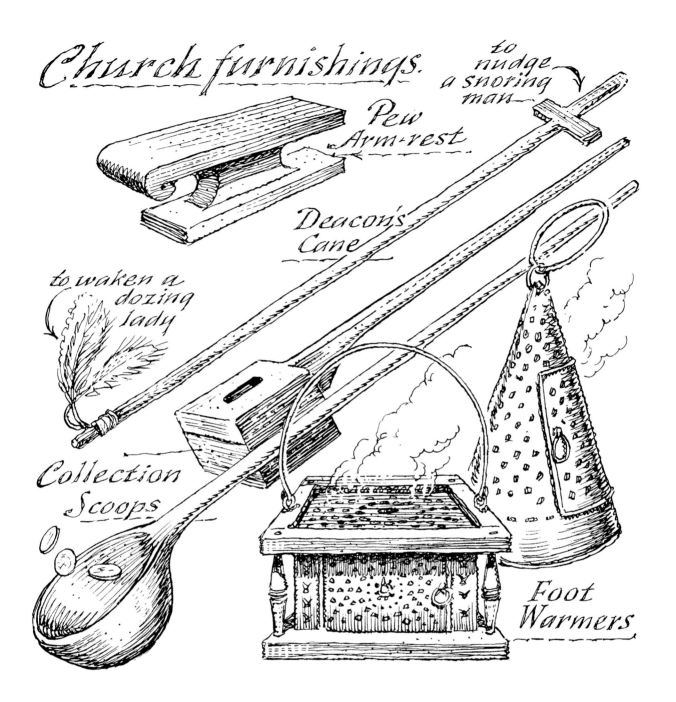

bath Day house) where babies could be nursed, food prepared and hot coals supplied to foot-warmers. Services lasted throughout the day, with hour–long sermons.

The furnishings of the old–time church are vanished items; collection ladles, church pew armrests, foot-warmers and deacon's canes which nudged a snoring gentleman or tickled a dozing lady to

bring them back to attention, are antique nostalgia. It was a far cry from the present day Sunday but it was what people accepted as the Sabbath.

In the old days, villages began with a church on a surrounding green and then homes were built around that area. But the tall spire protruding above the trees always marked the town's central location. Now, new areas grow up around roadside supermarkets and then a central bank is added. The old-time churches remain in the quieter parts of town, not as well attended now as they were once upon a time.

An important part of the early American church was its adjoining graveyard. Here and there where the church building had been burned or destroyed, the site is still marked by ancient gravestones which are evidence of the way we once regarded both life and death, with a hearty and equal respect for both. Nowadays death is something seldom discussed, but once upon a time death was considered a part of life, and not feared nor hushed. Even children were aware of death and young girls often made rhymes about it to sew into samplers. Today the graveyard is a dreaded place where vandals seem to enjoy upturning tombstones, the last place one would go for a picnic or Sunday outing, as country people used to do.

Stonecutting was not a full time occupation and so many of the old grave markers were made by farmers, blacksmiths, cobblers or anyone who "had a hankering" for stone carving. Gravestone art was documentary in presenting the mood of early America, evidence of a fine sense of humor, a reverence for life, an awareness of the dignity of death and a primitive attempt to portray the deceased.

The old gravestones had a sense of humor, a sense of the mystic, a sense of respect, a sense of hereafter.

Postscript

"The same sand that passed through, is used to count the hours of the future."

Logically, yesterday is gone forever yet spiritually the past (whether two centuries ago or only two minutes ago) is still an important part of the present. Science has progressed and times have so changed that America's "once upon a time" seems like a thousand years ago, but it was the birth which resulted in what we are today.

The spirits and habits of yesterday become more difficult to apply to modern everyday life. You never could grow pumpkins on Main Street but the whole nation is becoming a vast Main Street. The American heritage, however, is a lot more than yesterday's pumpkins or romantic nostalgia, and if we can only mark time with our scientific progress long enough to let the old morals and spirits catch up, we shall be all the better for it. The heritages of godliness, the love of hard work, frugality, respect for home and all the other spirits of pioneer countrymen, are worth keeping forever. What we do today will soon become once upon a time for the Americans of tomorrow and their heritage is our present day responsibility.